LET'S KEEP IT CLEAN!
COLORING BOOK

STOP IT

BUZZ into it!

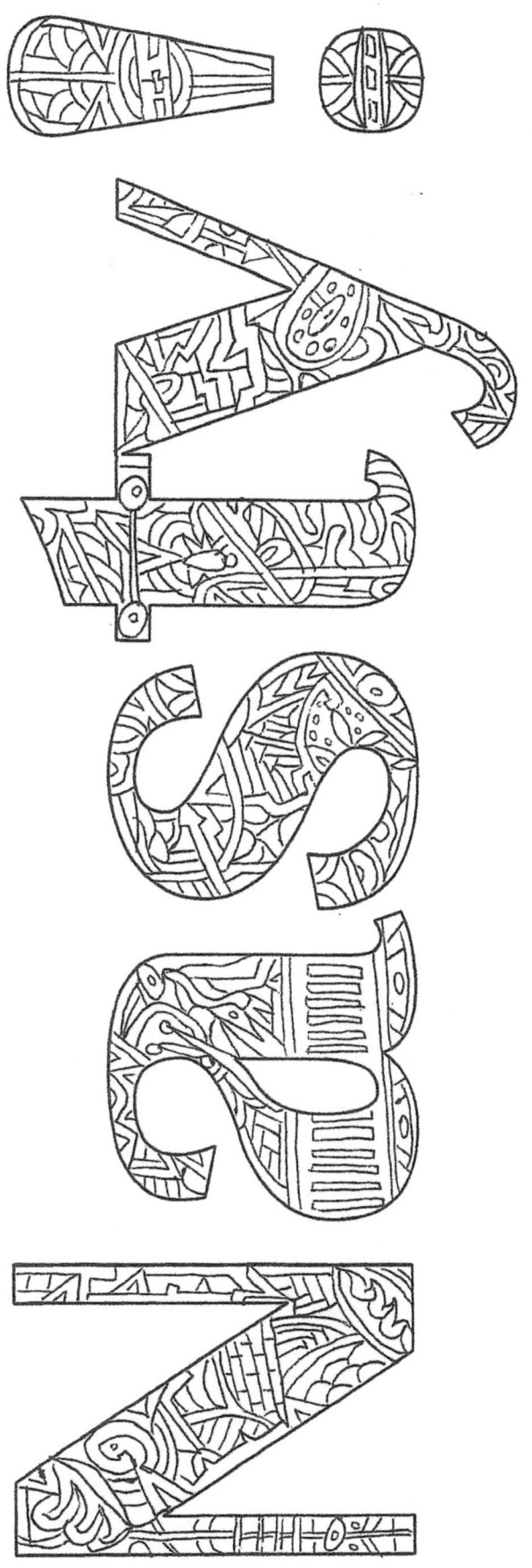

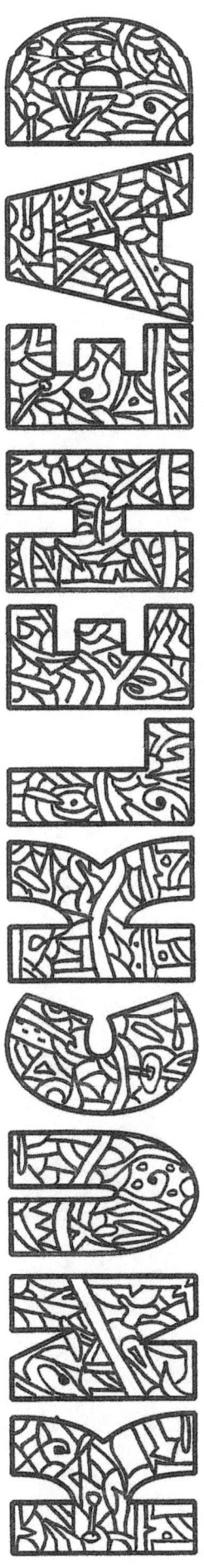

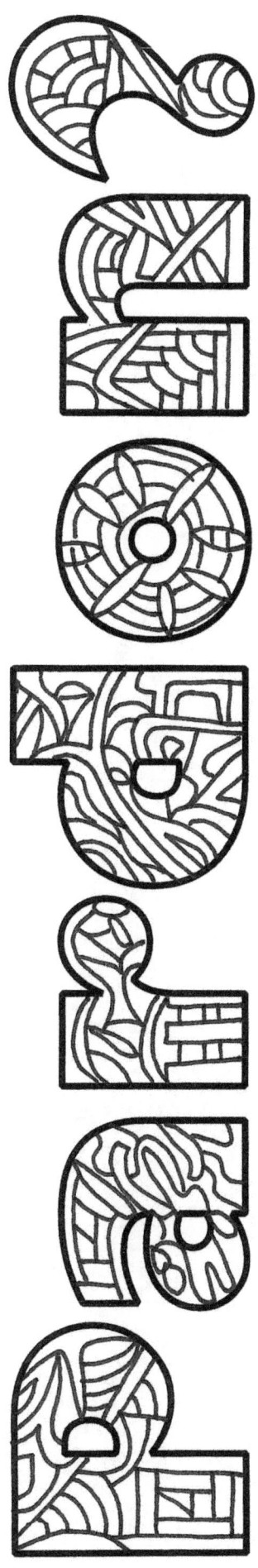

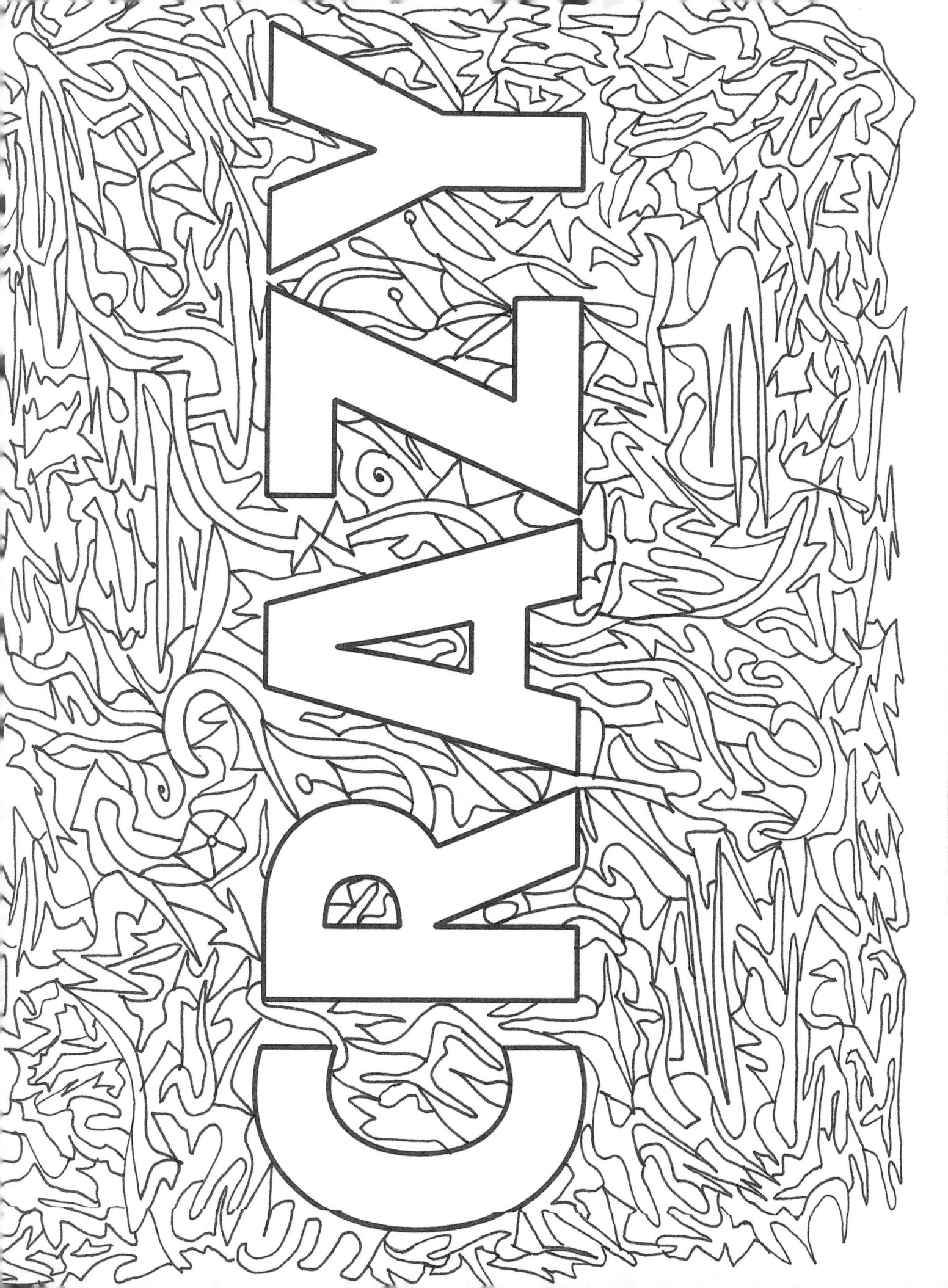

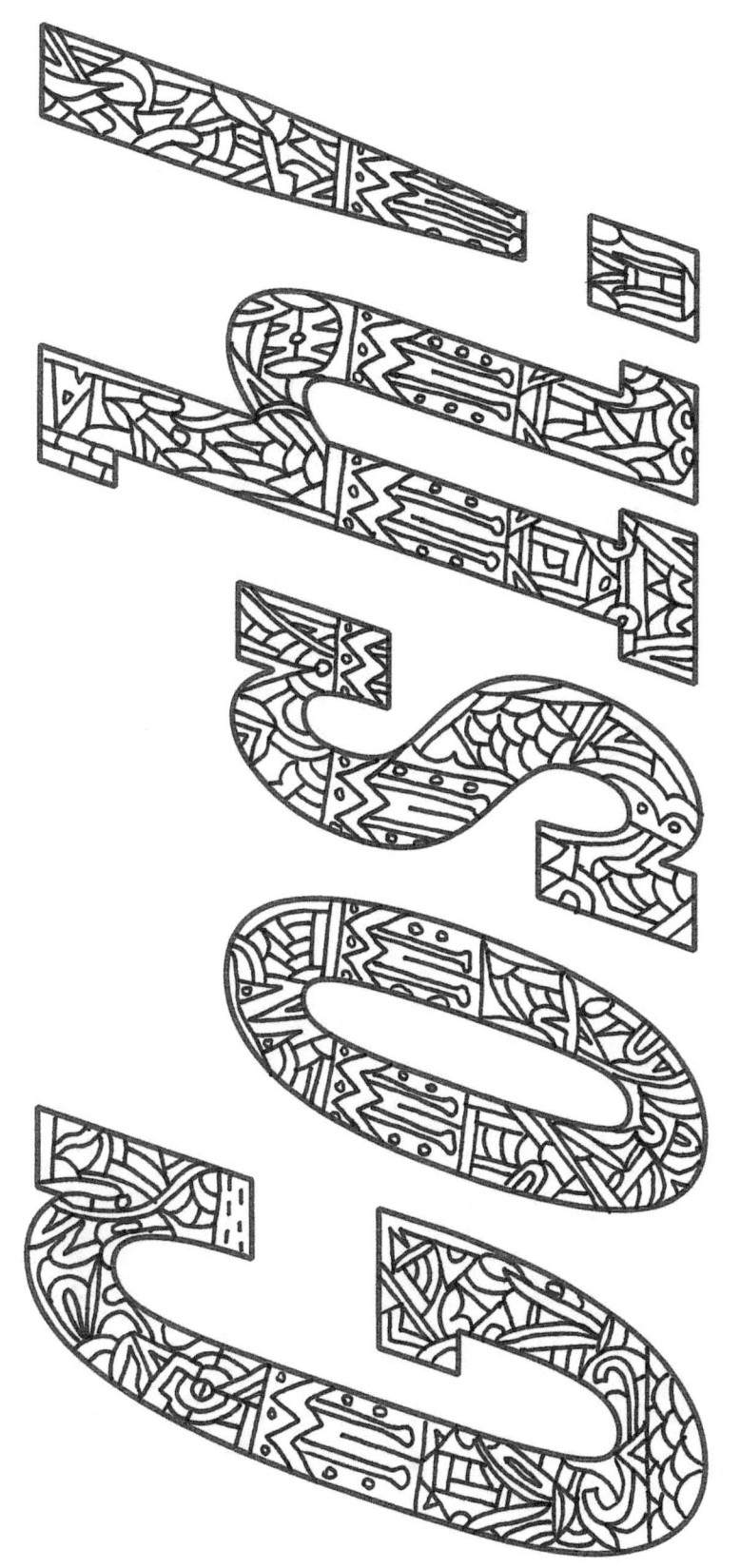

What the heck?

What in tarnation?

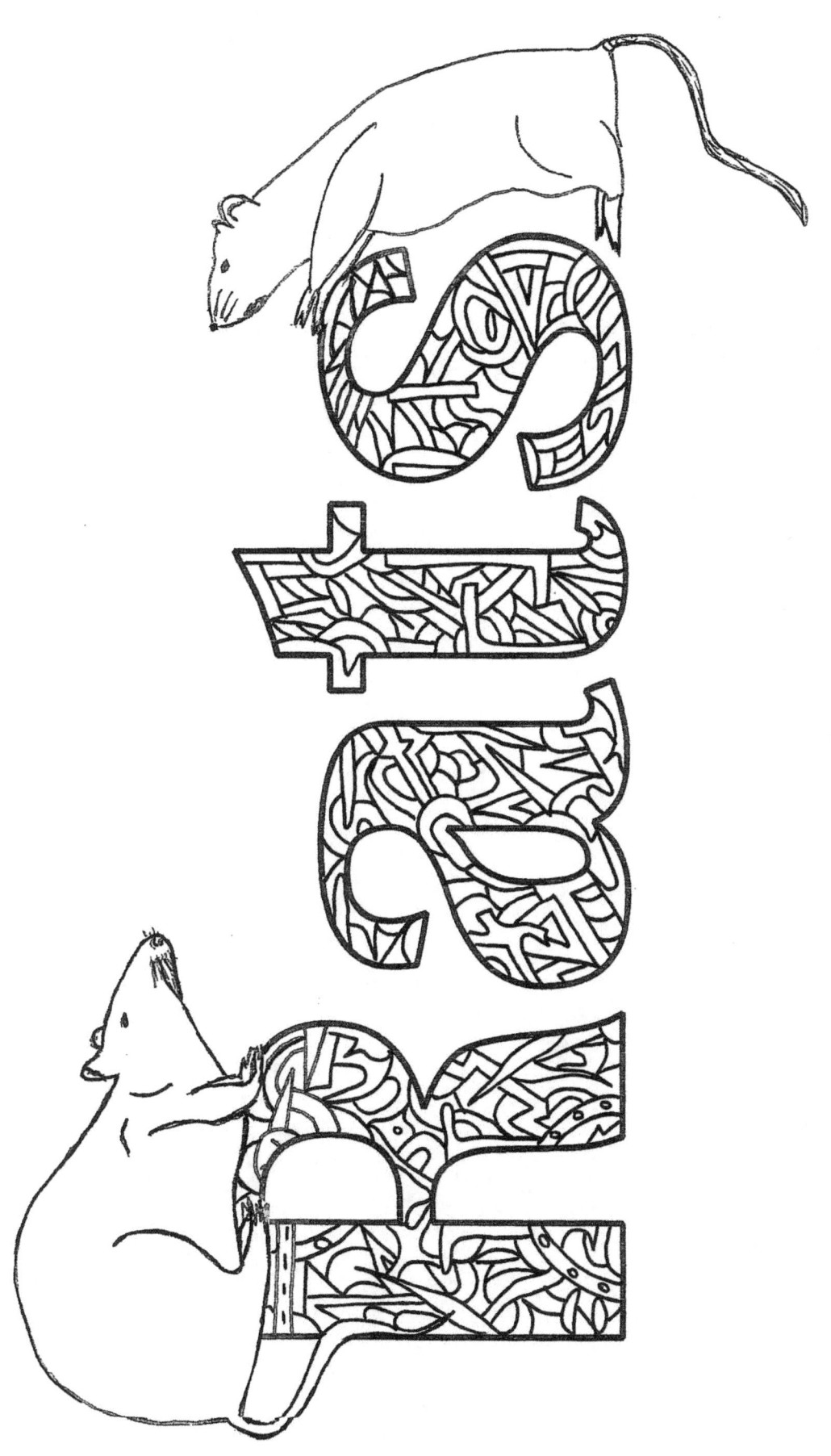

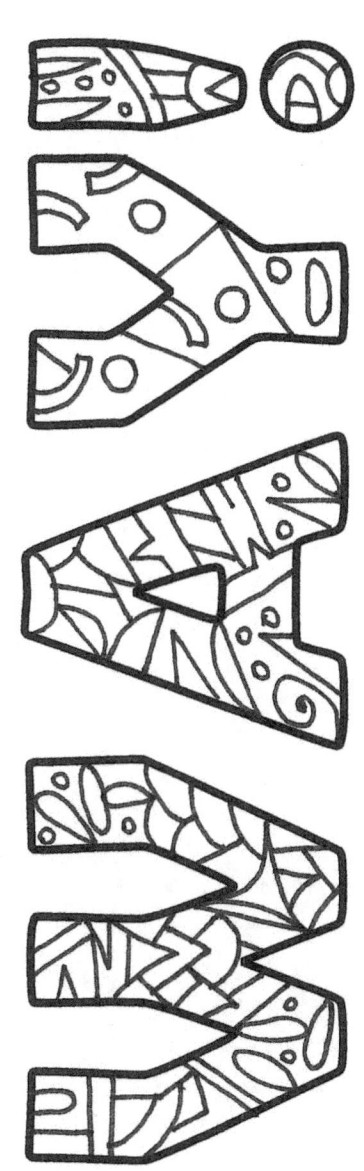
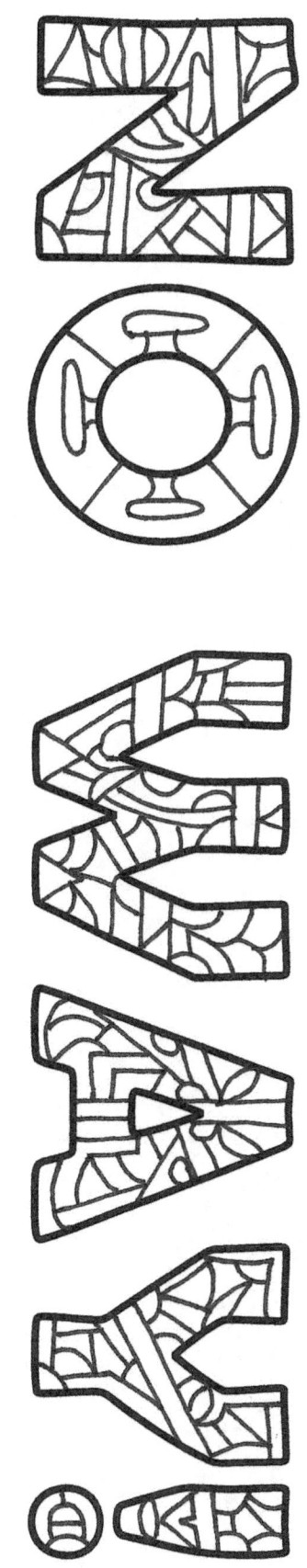